DATE DUE

JAN 2 9 2001		
MAR 1 1		

DEMCO 38-296

LIBRARY
Arcata High School

DEMCO

MATISSE
BY

DISCARDED

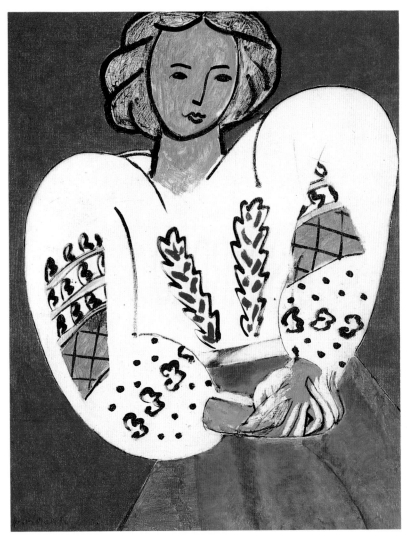

The Blouse, 1940, National Museum of Modern Art, Paris

MATISSE
BY

ARTISTS BY THEMSELVES
EDITED AND WITH AN INTRODUCTION
BY RACHEL BARNES

BRACKEN
BOOKS

Introduction text Copyright ©1990 Rachel Barnes
Series devised by Nicky Bird

This edition published 1992 by The Promotional Reprint
Company Limited exclusively for Bracken Books, an
imprint of Studio Editions Limited, Princess House, 50
Eastcastle Street, London W1N 7AP England.

ISBN 1 85170 980 0

CONTENTS

Introduction 6
Matisse by Matisse 18

Chronology 78
Acknowledgements 80

INTRODUCTION

I have always tried to hide my own efforts and wished my
works to have the lightness and joyousness of springtime
which never lets anyone suspect the labour it has cost. So I
am afraid that the young, seeing in my work only the apparent
facility and negligence of the drawing, will use this as
an excuse for dispensing with the certain efforts which I
believe necessary.

Matisse was nearly eighty when he wrote these words in a letter
reflecting on his extraordinary career as a painter, sculptor,
draughtsman, decorator and theorist. His dedication to his art
throughout a long life was total and every painting, every work, was
the product of painstaking care and thought. Few painters have
succeeded in expressing so much joy in their work, but 'the anxious,
the madly anxious Matisse', as his friend Richard Cross called him,
did not possess the relaxed, insouciant temperament his painting
might suggest. On the contrary, it was his nervous and obsessively
methodical personality that demanded the escape and solace of 'an
art of balance, of purity and serenity, devoid of troubling or
depressing subject matter' ('Notes of a Painter', 1908).

Henri Matisse was born at Le Cateau-Cambrésis in the North of
France in 1869. Unlike the biographies of many painters, there are
no stories of the child drawing in early boyhood: painting for
Matisse developed with maturity. It was actually when he was
convalescing from appendicitis as a young man of twenty that his
mother presented him with his first box of paints. He later wrote of

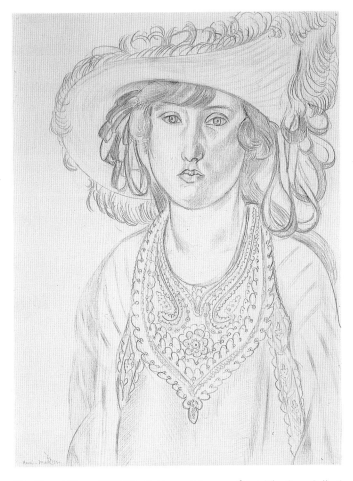

The Plumed Hat, c 1919, The Baltimore Museum of Art: The Cone Collection, formed by Dr Claribel Cone and Miss Etta Cone of Baltimore, Maryland.

the wonderful feeling of escape into 'a kind of paradise' which he experienced with these first fumbling efforts. He felt for the first time in his life that he was 'free, solitary and quiet'. It was the beginning of a spell that would last for the next sixty-four years, until his death in 1954. For Matisse, the art of painting was never to lose this sense of entering another world.

Like his great hero Cézanne, Matisse was pressurized by his family into pursuing a career in law, until finally he rebelled and persuaded his father to allow him to study art under Bouguereau at the Académie Julian. The tuition of Gustave Moreau, to whom he went next, was to have a more liberating effect, however, especially since it was in this class at the École des Beaux-Arts that he met painters with similarly progressive ideas, like Georges Rouault and Albert Marquet. But the real beginnings of his independent development as a painter can be traced to the summer of 1896, which Matisse spent at Belle-Ile with the painter Emile Wéry. Later, he wrote of this time:

In about 1896, when I was at the École des Beaux-Arts, I was living on the Quai Saint-Michel and the painter Wéry was my next door neighbour. He was influenced by the Impressionists, Sisley in particular. One summer we went to Brittany, to Belle-Ile-en Mer. While working next to him I noticed that he achieved more luminosity using primary colours than I could with my palette, which was that of the Old Masters. This was the first stage of my evolution, and I returned to Paris liberated from the influence of the Louvre; I was heading towards colour.

The move towards colour – pure colour which justifies its own

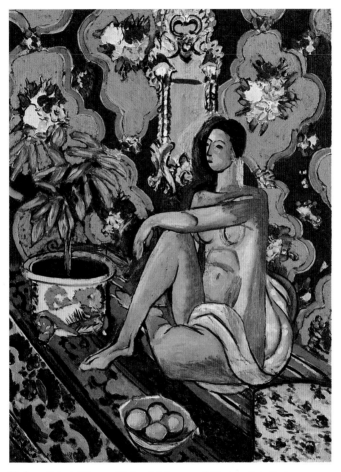

Nude on Oriental Carpet, National Museum of Modern Art, Paris

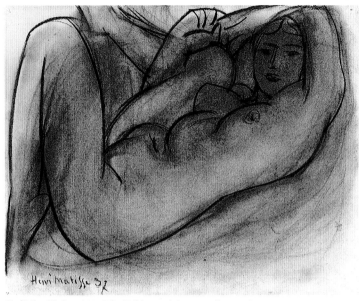

Reclining Nude, 1937, The Baltimore Museum of Art: The Cone Collection, formed by Dr Claribel Cone and Miss Etta Cone of Baltimore, Maryland.

existence – was not to be realized fully for another nine years. Meanwhile, in 1898 Matisse married Amélie Parayre; the couple celebrated with a honeymoon in London where, on Pissarro's advice, Matisse went to see the paintings of Turner, which impressed him with their highly expressive use of colour.

The few years which followed were the most difficult both practically and financially that the artist was to endure before he began to sell his work. Madame Matisse opened a small millinery shop in the Rue Châteaudun in Paris, whilst their three children

went to stay with their grandparents. Matisse took a job as a painter and decorator to supplement the meagre family income. Despite the considerable poverty and hardship of these years, in 1899 Matisse gathered his slender resources to buy Cézanne's 'The Three Bathers', a work which was to exert a profound influence on him and to become a sort of talisman in the years to come. When, years later, he donated it to the Musée de la Ville, he wrote to the director, Raymonde Escholier:

> I have owned this canvas for thirty-seven years and I know it fairly well, I hope, though not entirely. It has sustained me spiritually in the critical moments of my career as an artist; I have drawn from it my faith and perseverance.

As this letter shows, it was not so much that the painting had a direct stylistic influence on his work, but that it exerted a sustaining, spiritual power. In view of this, it is interesting to note that Cézanne is one of the few painters to rival Matisse in his dedication to his art.

But the final anarchic severance with previously held conventions still lay ahead. In 1936 Matisse, with his customary insight, was to comment to Tériade upon his gradual realization that a complete reassessment of artistic values was essential to his progress:

> When the means of expression have become so refined, so attenuated that their power of expression wears thin, it is time to return to the essential principles which made human language. They are principles which 'return to the source' take new life, give life... pictures which here become refinements, subtle degradations, dissolutions without force, call for beautiful blues, reds, yellows, matter to stir the sensual depths

in men. It is the starting point of Fauvism; the courage to return to purity of means.

In 1905, Matisse painted 'Luxe, Calme et Volupté', which showed that he had developed his influences from the Neo-Impressionists and Post-Impressionists to create a new style, conveying the sense of joy and tranquillity which was to dominate his work from then on. The couplet from Baudelaire's 'L'invitation au Voyage', from which he took the title, seems to sum up the fundamental purpose of his art.

> La tout n'est qu'ordre et beauté
> Luxe, Calme et Volupté.

When Raoul Dufy saw the painting he was deeply impressed by what he referred to as 'the miraculous imagination of the draughtmanship and the colour'. This key work was exhibited at the Salon des Indépendants in 1905. Later that year Matisse, Derain, Marquet, Friesz, Rouault, Puy and Vlaminck all exhibited together at the famous show at the Salon d'Automne.

The extraordinary violence of both colour and execution astounded critics and public alike. Looking at the works now, some eighty years later, the raw power that so shocked everyone who saw them is still evident, and it is not difficult to imagine the effect that they had on a conservative audience, ill-prepared for such radicalism. The critic Louis Vauxcelles observed that it was 'a real fireworks display' and, pointing to a small bronze of a child made in the manner of the quattrocento by Albert Marquet, he was supposed to have exclaimed, 'Ah – Donatello au milieu des fauves!' Whether or not he actually made this remark, the term 'les fauves'

– the wild beasts – stuck, in the somewhat inappropriate way typical of the naming of movements in art. From this time on Matisse became the guiding force of the movement – Fauvism – which only just predated the beginning of Cubism, led by Picasso and his famous painting 'Les Demoiselles d'Avignon' of 1907, and of the Expressionist movement in Germany.

It was a crucial time, not only in the history of Western art, but also in Matisse's own career. Towards the end of his life, he described his state of mind at the time:

> Although I knew I had found my true path... I took fright, realizing that I could not turn back... so I charged head down... urged forward by I know not what – a force that I see today is quite alien to my normal life as a man.

Matisse's years prior to the birth of Fauvism were, in a sense, a preparation for this moment, and the exhibition of 1905 was a turning point. It was very important to him that the effects of this culmination should endure and not be a transitory event and, although his art was to progress through many more stages, the vibrance of the colours in the early days of Fauvism was to remain constant. As he later explained:

> Fauvism sprang from the fact that we got far away from colours of imitation. By using pre-colours only, we achieved more powerful results – simultaneous results which were more immediate and there was also the luminosity of the colours.

Matisse's 'Notes of a Painter', first published in *La Grande Révue* in

December 1908, a couple of years after the initial furore caused by the 1905 exhibition, is amongst the most perceptive and revealing of statements by any twentieth-century painter. Unlike Picasso, who intensely disliked being questioned about his art and, when he was prevailed upon to elucidate, was often deliberately confusing, Matisse was candid and illuminating. It was not for nothing that he referred to his and Picasso's paradoxical natures as 'the North and South poles'. Matisse possessed an essentially intellectual view of art which he was able to express with great fluency. One of his most frequently quoted statements in the 'Notes' of 1908 has, however, caused some controversy and has been open to misinterpretation.

What I dream of is an art of balance, of purity and serenity, devoid of troubling or depressing subject matter, an art which might be for every mental worker, be he businessman or writer, like an appeasing influence, like a mental soother, something like a good armchair in which to rest from physical fatigue.

How, it has been asked, can a painter who revolutionizes the entire history of art with a portrait of his wife with a green stripe down her face ('Portrait of Madame Matisse', 1905, see p.27) claim to aspire to an art 'devoid of troubling subject matter'? The point was, of course, that the notorious green stripe was not intended to disturb, and the longer the viewer looks at the painting the clearer it becomes that it does not do so, but that aesthetically it actually balances the entire composition.

As his career progressed, Matisse's art increasingly became a solace and a refuge – not just for the artist himself, but also for the public. To find inspiration, he needed to travel: rather like Van Gogh, Matisse was a Northern European who loved the sun and was inspired by the brilliant colours of a Mediterranean climate. In

the winter of 1916 he went to Nice to stay at the Hôtel Beau-Rivage. Initially it was rather overcast, but as the days grew sunnier and warmer Matisse fell in love with this part of the South of France, returning there every winter and finally accepting the famous commission for the decorations in the Chapelle du Rosaire in 1948. By the end of his life, Matisse was so closely associated with this region of France that a site on the hillside of Cimiez above Nice was chosen for the museum dedicated to his work.

Matisse also liked to travel further afield. He first went to Morocco in 1911, finding inspiration both in the landscape and the people: it was at this time that he began his famous 'Odalisques' series. In 1930 he travelled in Gauguin's footsteps to Tahiti, journeying via New York and San Francisco. But, although the moods and changing colours of nature were always to excite his artist's eye, the human figure, and especially the female form, was his most constant source of ideas and inspiration. 'What interests me

The Sadness of the King, 1952, National Museum of Modern Art, Paris

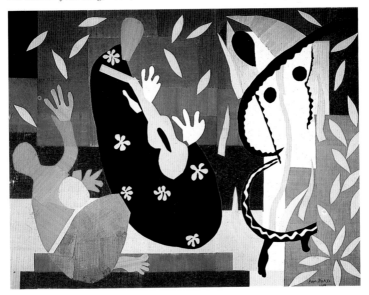

most', he wrote in the 'Notes' of 1908, 'is neither still life, nor landscape, but the human figure. It is through it that I succeed in expressing the almost religious feeling I have towards life'. Matisse painted many self portraits, as well as portraits of his wife and his daughter Margueritte. He wrote that a portrait demanded 'the complete identification of the painter with his model. It is by getting inside the subject that one gets inside one's own skin.' But, by his own admission, he was as demanding of his models as of himself:

> For more than fifty years I haven't stopped working an instant. From nine to twelve first session, then lunch. Then I have a short rest and go back to my brushes until nightfall. You wouldn't believe me. Every Sunday, I am obliged to tell all sorts of fibs to my models. I promise them I will never ask them again to pose that day. Of course, I pay them double. Finally when I feel they are not convinced I swear I'll give them a day off in the week. 'But, Monsieur Matisse', one of them answered me, 'this has been going on for months and I have never had an afternoon free.' Poor things. They can't understand it...

Perhaps unexpectedly for a painter who was so completely motivated by colour, Matisse's genius is never so evident as in his drawings – in a few beautifully balanced lines he can express perfectly the character or beauty of his sitter. His work as a sculptor also became of increasing importance to him, and many believe him to have been as gifted a sculptor as he was painter.

But it was in his work with his famous paper cut-outs, begun late on in his career in 1947, that Matisse – like the mature Titian or Rembrandt – went on to express the knowledge of a lifetime with

breathtaking sureness and simplicity. 'Cutting into living colour reminds me of the sculptor's direct carving,' he wrote. In the best of these *gouaches découpées* such as 'L'Escargot' or the series of 'Blue Nudes' (see p.73) he achieves a near perfect sense of rhythm and movement 'an art of balance, of purity and serenity'.

Matisse's writings are of great importance, not necessarily in order more fully to appreciate his paintings – they speak for themselves – but to understand what motivated him. He was very self critical, and usually clear sighted about his limitations as well as his strengths. Although he was anarchic, deliberately breaking with tradition, he was, paradoxically, tremendously indebted to painters from the past. His statements often reveal a curious mixture of caution and boldness.

At the end of his life, he explained how his rôle as an artist had always been to interpret nature, rather as a person in love projects ideas and feelings onto the love-object:

It is always when I am in direct accord with my sensations of nature that I feel I have the right to depart from them, the better to render what I feel. Experience had always proved me right... For me nature is always present. As in love, all depends on what the artist unconsciously projects on everything he sees. It is the quality of the projection, rather than the presence of a living person, that gives an artist's vision its life.

Self Portrait
1906

State Museum of Art, Copenhagen

I am a romantic, yes, but also to a great extent a scientist and a rationalist. This creates the conflict from which I emerge occasionally victorious, but out of breath.

Letter to Charles Camoin, Paris, Autumn 1914

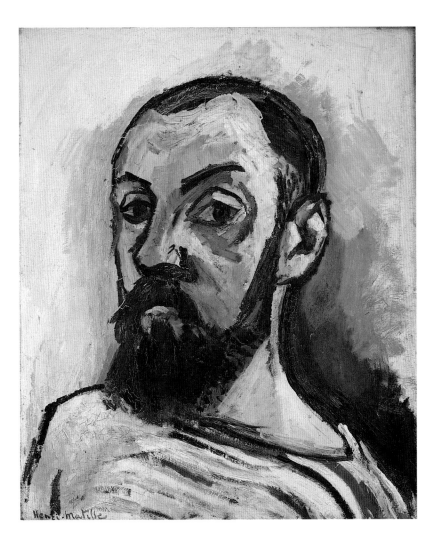

Rocks and Sea
1897

Private Collection, Paris

In about 1896, when I was at the École des Beaux-Arts, I was living on the Quai Saint-Michel and the painter Wéry was my next door neighbour. He was influenced by the Impressionists, Sisley in particular. One summer we went together to Brittany, to Belle-Ile-en-Mer. While working next to him I noticed that he achieved more luminosity using primary colours than I could with my palette, which was that of the Old Masters. This was the first stage of my evolution, and I returned to Paris liberated from the influence of the Louvre; I was heading towards colour.

Conversation with Tériade, cited in 'Matisse Speaks'
Art News Annual No 21, 1952

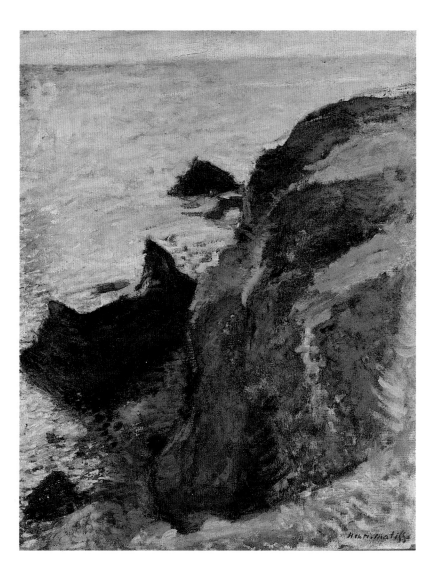

Vase of Magnolia
1904

National Museum of Modern Art, Paris

Everything should come to mind in the same way that smells come to you in a landscape. Those of the earth, of the flowers, linked to the playing of the clouds, to the movements of the trees and to the various sounds of the countryside.

Cited in Raymonde Escholier, 'Matisse, ce vivant'
Librairie Arthème Fayard, 1956

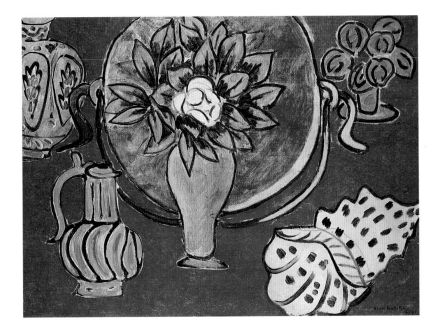

André Derain
1905

Tate Gallery, London

At the time of the Fauves, what created the strict organization of our work was that the quantity of colour was its quality. It had to be right from all points of view. That is what was appropriate then. The people who saw painting from the outside were made uneasy by the schematic state of certain details. Hands, for example, Renoir painted progessively according to his feeling, sensation by sensation. We ourselves were preoccupied with the measure of the plastic ensemble, with its rhythm, with the unity of its movement. Thus we were accused of not knowing how to paint a hand or how to draw any other detail. Nothing could be more false. It was simply that the state of our pictorial problem did not permit us to go all the way to the perfection of details.

The only thing one should ask of a painter is that he express his intentions clearly. His thought will profit from this. As for those who, preoccupied with the precious aspect of their works, begin with perfection, the spirit of the École [des Beaux-Arts] and of the Prix-de-Rome is with them. Without going so far as to encourage certain painters for whom the language no longer exists, I think that the young who will have something to say and who will go beyond the means along the way, will say it anyway.

Extract from *Statements to Tériade*, 1929-30

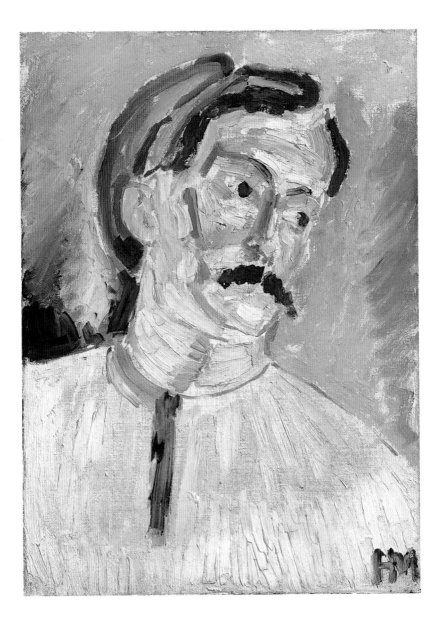

Portrait of a Woman with Green Stripe
1905

State Museum of Art, Copenhagen

In a drawing the character of a face does not derive from its various proportions but from the spiritual light which is reflected in it.

Extract from *Jazz*, 1947

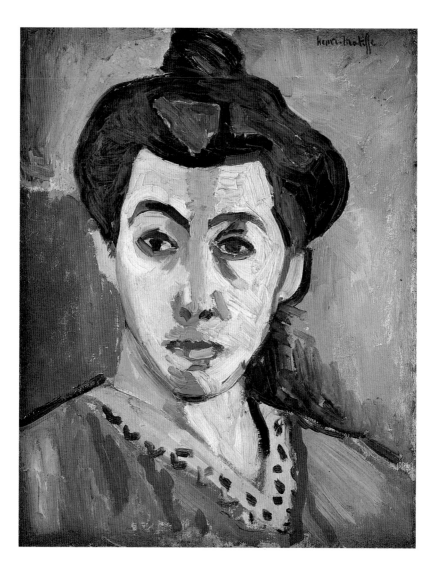

Window
1905

Everything is new ... everything is fresh, as if the world had just been born; a flower, a leaf, a stone, everything shines, everything shimmers, everything glistens as if it were polished, you can't imagine how beautiful it is. Sometimes I think that we profane life itself. We are so used to seeing things that we no longer look at them. We experience them only in a superficial way. We don't feel any more. We have become blasé.

Cited in Louis Gillet, 'A Visit to Henri Matisse'
Candide, 24 February 1943

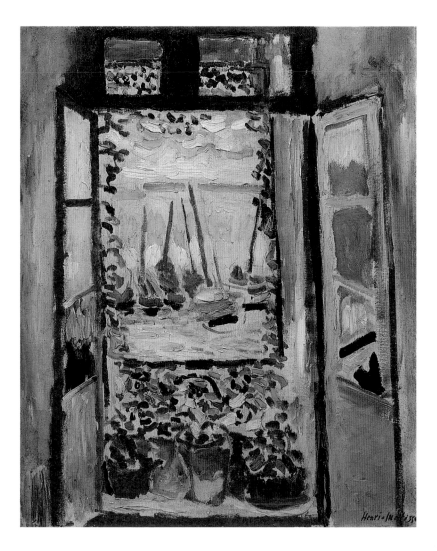

Still Life with a Red Carpet
1906

Photograph: Andre Morin
Musee de Grenoble

With more involvement and regularity, I learned to push each study in a certain direction. Little by little the notion that painting is a means of expression asserted itself, and that one can express the same thing in several ways. 'Exactitude is not truth', Delacroix liked to say. Notice that the classics went on re-doing the same painting and always differently. After a certain time, Cézanne always painted the same canvas of 'The Bathers'. Although the master of Aix ceaselessly redid the same painting, don't we come upon a new Cézanne with the greatest curiosity? Apropos of this, I am very surprised that anyone can wonder whether the lesson of the painter of the 'Maison du Pendu' and the 'The Card Players', is good or bad. If you only knew the moral strength, the encouragement that his remarkable example gave me all my life – in moments of doubt, when I was still searching for myself, frightened sometimes by my discoveries, I thought: 'If Cézanne is right, I am right'; because I knew that Cézanne had made no mistake. There are, you see, constructional laws in the work of Cézanne which are useful to a young painter. He had, among his great virtues, this merit of wanting the tones to be forces in a painting, giving the highest mission to his painting.

<div align="right">Interview with Jacques Guene</div>

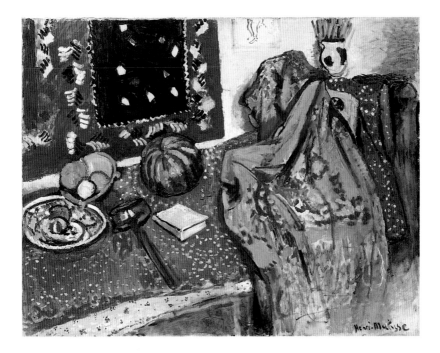

Le Luxe

1907

National Museum of Modern Art, Paris

One last comment on the name of that school of painting known as 'Fauvisme', a word which was found so intriguing and which became the subject of many more or less apt witticisms. The phrase originated with the art critic Louis Vauxcelles who, on coming into one of the rooms of the Autumn Salon, where, among the canvases of that generation, a statue was on view executed by the sculptor Marque in the style of the Italian Renaissance, declared 'Look, Donatello among the beasts'. This shows that one must not attach more than a relative importance to the qualifying characteristics which distinguish such and such a school, and which, in spite of their convenience, limit the life of a movement and militate against individual recognition.

Extract from *Statements to Tériade*, 1936

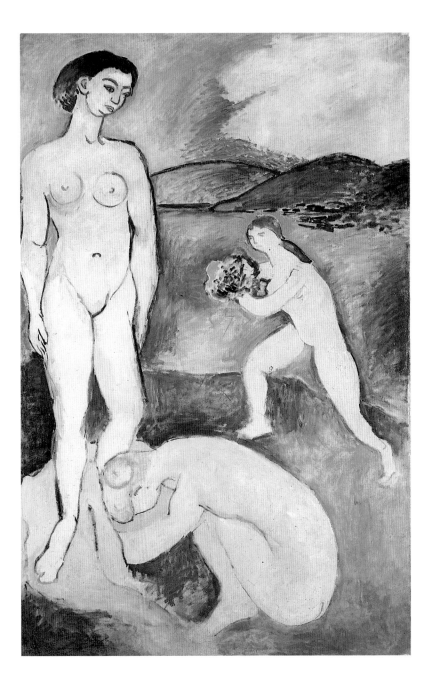

The Dance

1909

The significance of a work of art varies according to the period in which you are looking at it. Should we confine ourselves to our own time and consider the work with today's fresh new sensibility, or should we study the period during which it was created, place it back in its own time and see it with the eyes of the people of those days, and in the context of parallel creations (literature, music) so as to understand what the work signified when it was conceived and what it meant to its contemporaries?

Conversation with Tériade, cited in 'Matisse Speaks'
Art News Annual No 21, 1952

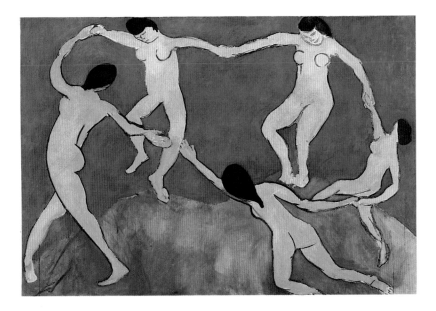

Girl with a Black Cat (Marguerite Matisse)
1910

Private Collection, Paris

When the means of expression have become so refined, so attenuated that their power of expression wears thin, it is necessary to return to the essential principles which made human language. They are, after all, the principles which 'go back to the source', which relive, which give us life. Pictures which have become refinements, subtle gradiations, dissolutions without energy, call for beautiful blues, reds, yellows – matter to stir the sensual depths in men. This is the starting point of Fauvism: the courage to return to the purity of the means.

Extract from *Statements to Tériade*, 1936

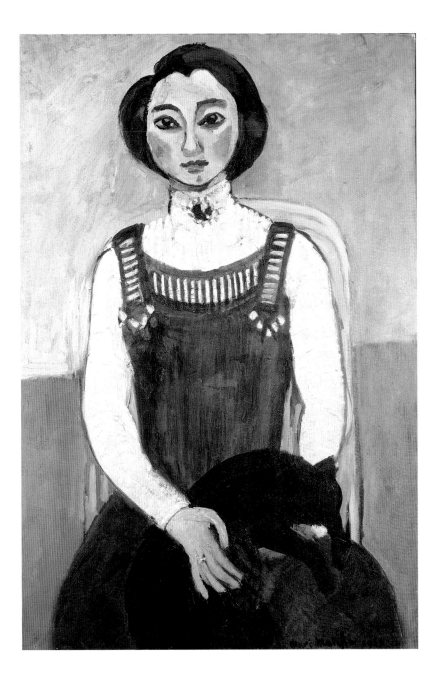

The Goldfish Bowl
1911

Pushkin Museum, Moscow

I have only very gradually discovered the secret of my art. It is in fact a meditation on nature, the expression of a dream which is always inspired by reality.

'Conversation with Henri Matisse'
L'Art Vivant, No 18, 15 September 1925

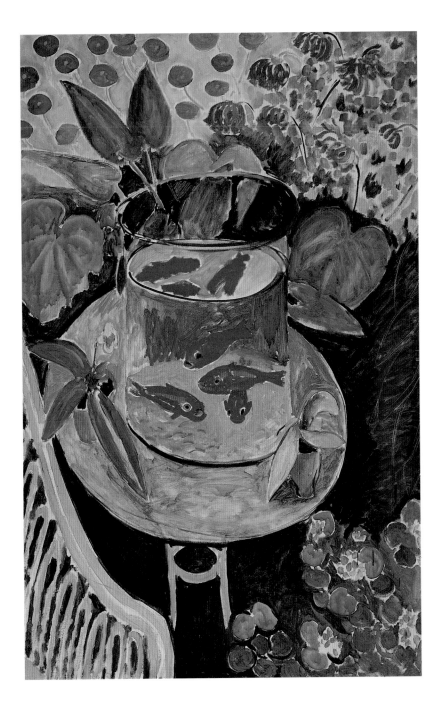

Moroccan Landscape
1911-13

Modern Art Museum, Stockholm
Photograph: Statens Konstmuseer

A distinction is made between painters who work directly from nature and those who work purely from imagination. Personally, I think neither of these methods must be preferred to the exclusion of the other. Both may be used in turn by the same individual, either because he needs contact with objects in order to receive sensations that will excite his creative faculty, or his sensations are already organized. In either case he will be able to arrive at that totality which constitutes a picture. In any event I think that one can judge the vitality and power of an artist who, after having received impressions directly from the spectacle of nature, is able to organize his sensations to continue his work in the same frame of mind on different days, and to develop these sensations; this power proves he is sufficiently master of himself to subject himself to discipline.

Extract from 'Notes of a Painter'
La Grande Revue, 1908

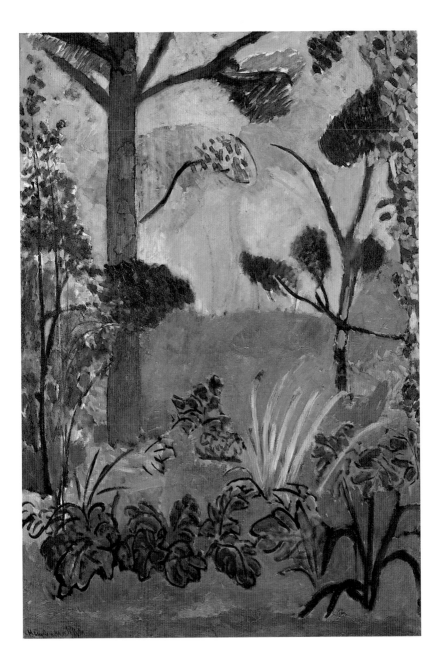

The Moroccans
1916

I find it difficult to describe my painting of 'The Moroccans' in words. It represents the point at which I began to express myself through colour, through shades of black and contrasting colours. It shows the figures of Moroccans stretched out on a terrace, with water melons and gourds.

Conversation with Tériade, cited in 'Matisse Speaks'
Art News Annual No 21, 1952

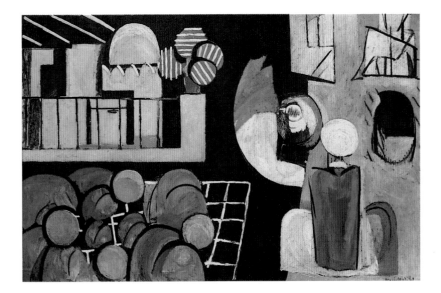

Trees Near Triveaux Pond
1916

Tate Gallery, London

I must define precisely the character of the object or of the body that I wish to paint. To do so, I study my method very closely: if I put a black dot on a sheet of white paper, the dot will be visible no matter how far away I hold it: it is a clear notation. But beside this dot I place another one, and then a third, and already there is confusion. In order for the first dot to maintain its value I must enlarge it as I put other marks on the paper.

If upon a white canvas I set down some sensations of blue, of green, of red, each new stroke diminishes the importance of the preceding ones. Suppose I have to paint an interior: I have before me a cupboard; it gives me a sensation of vivid red, and I put down a red which satisfies me. A relation is established between this red and the white of the canvas. Let me put a green near the red, and make the floor yellow; and again there will be relationships between the green or yellow and the white of the canvas which will satisfy me. But these different tones mutually weaken one another. It is necessary that the various marks I use be balanced so that they do not destroy each other. To do this I must organize my ideas; the relationship between the tones must be such that it will sustain and not destroy them. A new combination of colours will succeed the first and render the totality of my representation.

<div style="text-align: right">

Extract from 'Notes of a Painter'
La Grande Revue, 1908

</div>

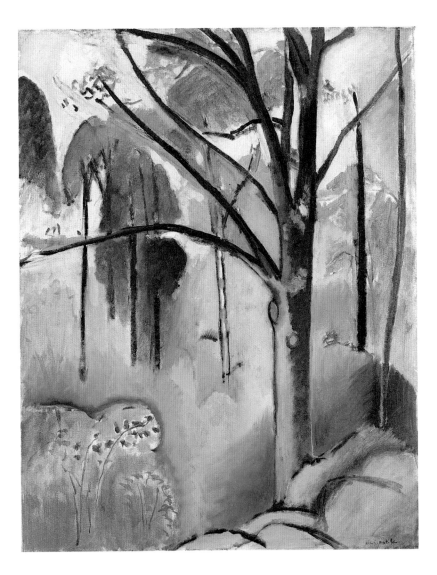

[45]

Reclining Model
1919

My definitive line drawings always contain their own area of light, and the objects of which they are made up appear on different planes; the perspective is that of feeling or of suggestion.

Cited in D. Fourcade (ed)
Henri Matisse, Writings and Ideas on Art, 1972

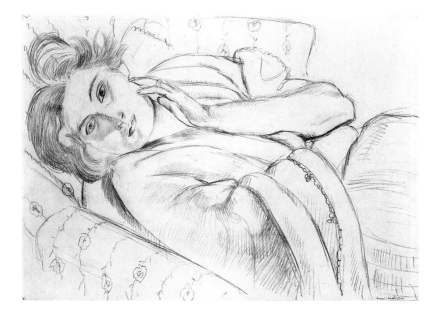

Lady with a Violin
1922

What interests me most is neither still life nor landscape, but the human figure. It is that which best permits me to express my almost religious awe towards life. I do not insist upon all the details of the face, on setting them down one-by-one with anatomical exactitude. If I have an Italian model who at first appearance suggests nothing but a purely animal existence, I nevertheless discover his essential qualities, I penetrate amid the lines of the face those which suggest the deep gravity which persists in every human being. A work of art must carry within itself its complete significance and impose that upon the beholder even before he recognizes the subject matter. When I see the Giotto frescoes at Padua I do not trouble myself to recognize which scene of the life of Christ I have before me, but I immediately understand the sentiment which emerges from it, for it is in the lines, the composition, the colour. The title will only serve to confirm my impression.

Extract from 'Notes of a Painter'
La Grande Revue, 1908

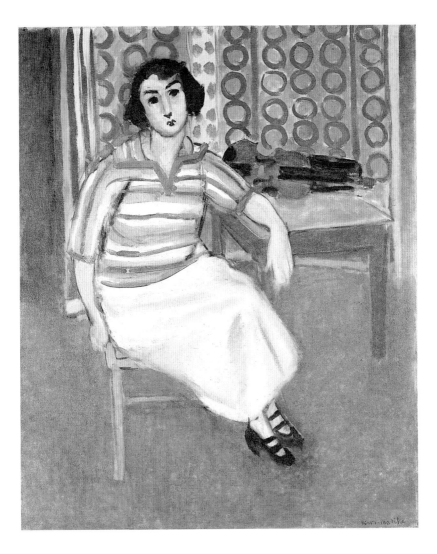

Odalisque
1923

Stedelijk Museum, Amsterdam

Suppose I want to paint a woman's body: first of all I imbue it with grace and charm, but I know that I must give something more. I will condense the meaning of this body by seeking its essential lines. The charm will be less apparent at first glance, but it must eventually emerge from the new image which will have a broader meaning, one more fully human. The charm will be less striking since it will not be the sole quality of the painting, but it will not exist less for its being contained within the general conception of the figure.

Extract from 'Notes of Painter'
La Grande Revue, 1908

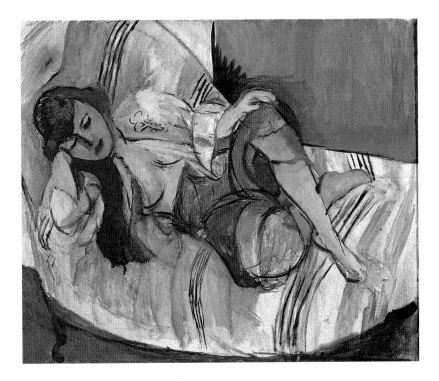

Anemones
1924

Kunstmuseum, Berne
Photograph: Hans Hinz

Once in the grip of the light I have often escaped in spirit from the small space immediately around my subject, the consciousness of which was, I think, enough for painters in the past – escaped from the space at the basis of the subject of my painting and felt, beyond me, beyond the subject, any studio, even beyond the house, a cosmic space within which one is as little aware of walls as is a fish in the sea.

Letter to Louis Aragon, 1 September 1942

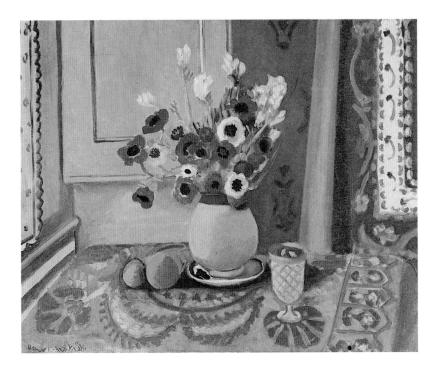

Odalisque

1926

I do Odalisques in order to do nudes. But how does one to the nude without it being artificial? And then, because I know that they exist. I was in Morocco. I have seen them. Rembrandt did Biblical subjects with real Turkish materials from the bazaar, and his emotion was there. Tissot did the Life of Christ with all the documents possible, and even went to Jerusalem. But his work is false and has no life of its own.

Extract from *Statements to Tériade*, 1929-30

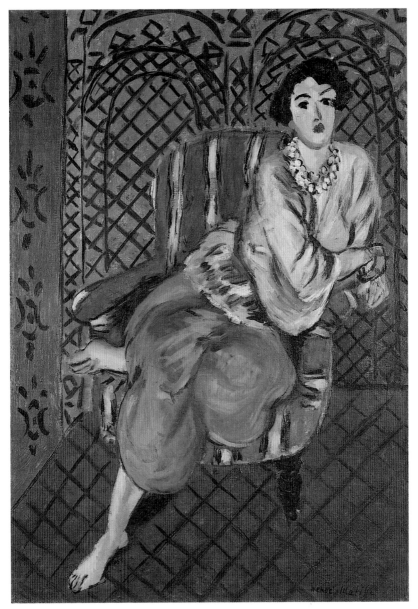

Odalisque Wearing Turkish Costume
1928

My models, human figures, are never merely features of an interior. They are the main theme of my work. I depend absolutely on my model, and I begin by observing her moving about freely. Then, afterwards, I decide on the pose which best corresponds to her nature; when I take a new model it is in how she is at rest that I find the pose that best suits her, and to which I become enslaved.

Extract from 'Le Point', July 1939

At that point it is best not to ask me any specific or down-to-earth question like 'What's the time?' because my reverie, my meditation around the model would be interrupted and the successful outcome of my work seriously compromised.

Extract from the preface to *Portrait*, 1954

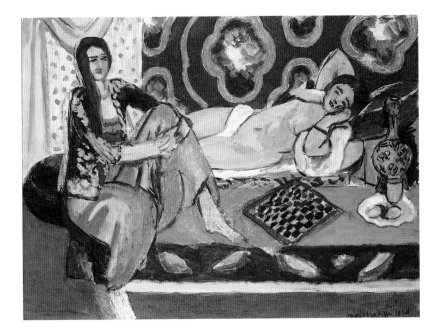

Model Resting on Her Arms
1936

Composition, the aim of which should be expression, is modified according to the surface to be covered. If I take a sheet of paper of a given size, my drawing will have a necessary relationship to its format. I would not repeat this drawing on another sheet of different proportions, for example, rectangular instead of square. Nor should I be satisfied with a mere enlargement, had I to transfer the drawing to a sheet of the same shape, but ten times larger. A drawing must have an expansive force which gives life to the things around it. An artist who wants to transpose a composition from one canvas to another larger one must conceive it anew in order to preserve its expression; he must alter its character and not just square it up onto the larger canvas.

Extract from 'Notes of a Painter'
La Grande Revue, 1908

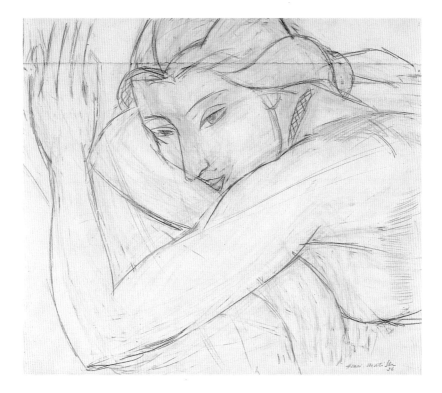

Music

1939

Albright-Knox Art Gallery, Buffalo, New York

Fauvism overthrew the tyranny of Divisionism. One can't live in a house too well kept, a house kept by country aunts. One has to go off into the jungle to find simpler ways which won't stifle the spirit. The influence of Gauguin and Van Gogh were felt then, too. Here are the ideas of that time: Construction by coloured surfaces. Search for intensity of colour, subject matter being unimportant. Reaction against the diffusion of local tone in light. Light is not suppressed, but is expressed by a harmony of intensely coloured surfaces. My picture 'Music' was done with a fine blue for the sky, the bluest of blues (the surface was coloured to saturation, that is to the point where the blue, the idea of absolute blue, was entirely evident), green for the trees and violent vermilion for the figures. With those three colours I had my luminous harmony, and also purity of colour tone. Note: the colour was proportioned to the form. Form was modified, according to the reaction of the adjacent areas of colour. For expression comes from the coloured surface which the spectator perceives as a whole.

The painter releases his emotion by painting; but not without his conception having passed through a certain analytic state. The analysis happens within the painter. When the synthesis is immediate, it is schematic, without density, and the expression suffers.

Extract from *Statements to Tériade*, 1929-30

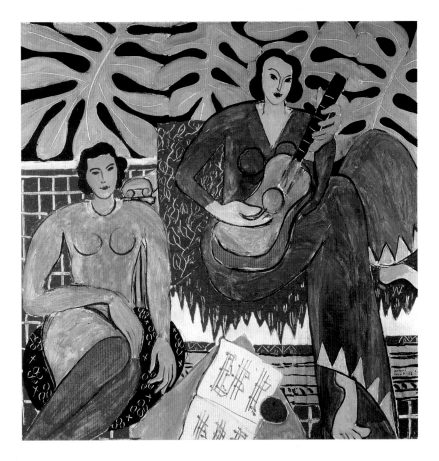

Girl Reading
1944

It takes a conscious effort to gear oneself up for creative work. Preparing a painting does not involve working on it in separate compartments. To prepare for its execution you have first to develop a feeling for it by doing studies which offer analogies with the painting, and it is then that the choice of elements can be made. It is thanks to these studies that the painter's unconscious can be set free.

Extract from 'Emancipation de la Peinture'
Minotaure Vol 1, Nos 3-4

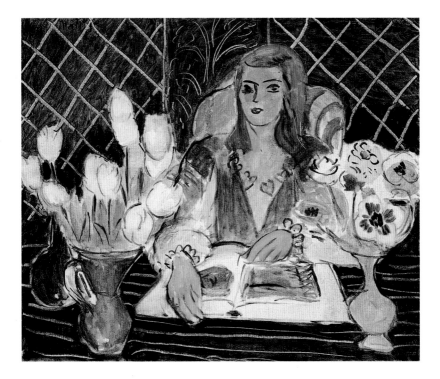

Still Life

1947

Musée Matisse, Nice

Why Nice? Shall I tell you?

I have attempted in my art to create a crystalline environment for the spirit; and I have found the limpidity I needed in several places around the world – New York, Oceania and Nice. If I had painted in the north, as I used to thirty years ago, my paintings would have been different. They would have been full of mist, of grey colours, the colours would have been downgraded by the perspective.

In New York, the local painters say 'You can't paint here, under this zinc-coloured sky'. In fact it's wonderful. It makes everything clear-cut, like crystal, precise, limpid. Nice has also helped me a great deal in this respect. You have to understand that what I paint are objects of the mind expressed through plastic means. If I close my eyes I can see these objects again, only more clearly than with my eyes open; all the little accidental things about them are removed – that's what I paint.

<div align="right">Conversation with Louis Aragon</div>

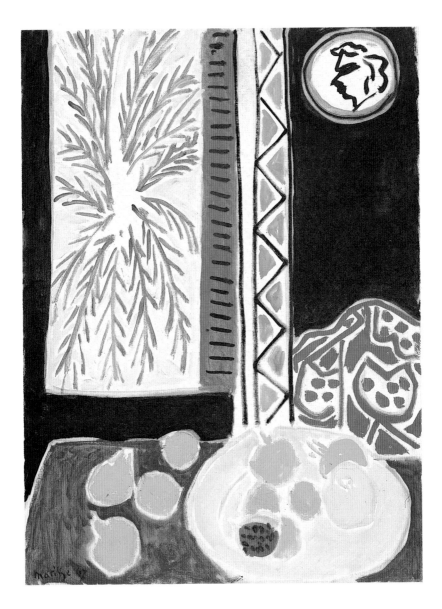

Plum Blossoms, Green Background
1948

What about the window?

My aim is to convey what I feel. The state of my soul is dictated by the objects that surround me, and that react within me – everything between the horizon and myself, including me. Very often when I stand in front of a painting I feel aware of what there is behind me.

I express space and the objects within it as naturally as if I had nothing before me but the sea and the sky, in other words the most simple things in the world.

'Visit to Henri Matisse'
L'Intransigeant, 14 and 22 January 1929

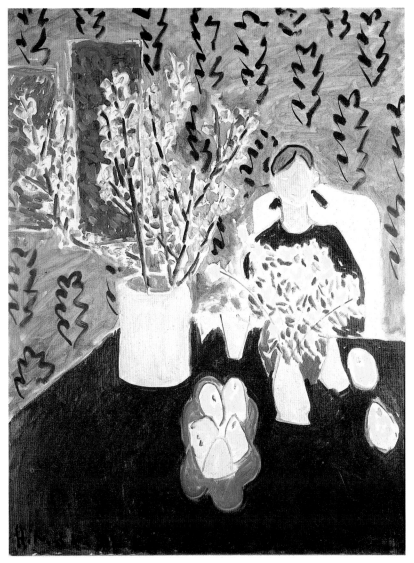

Madonna and Child
1949-51

Chapelle de Vence
Photo Hélène Adant, rights reserved

When I enter the Chapel I feel that the whole of me is there – I mean everything that was best in me when I was a child, and which I have tried to preserve all through my life.

Reported by Father Marie-Alain Couturier
Se Garder Libre, 1962

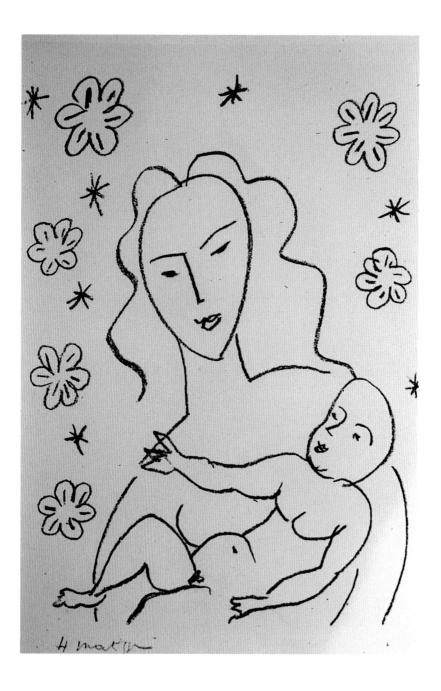

Via Crucis, Vence

1949-51

Chapelle de Vence

I have even given the chapel a spire, over twelve metres tall. And this spire, made of wrought iron, does not crush the chapel but, on the contrary, gives it height, because I conceived of it as a drawing – just like a drawing I would do on a sheet of paper – but a drawing that rises upwards. When you see a cottage, towards the end of the day, with smoke rising from its chimney, you watch the smoke rising and rising and it does not seem to stop at all.

My spire gave the same sort of impression.

Conversation with Georges Charbonnier

The stained-glass windows will reach from floor to ceiling and will be five metres tall.... They will be blocks of pure, very brilliant colour.

There will be no figures, just a pattern of shapes. Imagine the sun pouring in through the window. It will cast coloured reflections on the ground and on the white walls, a whole orchestra of colours.

Extract from 'Matisse Designs a New Church'
Vogue No 131-2, 15 February 1949

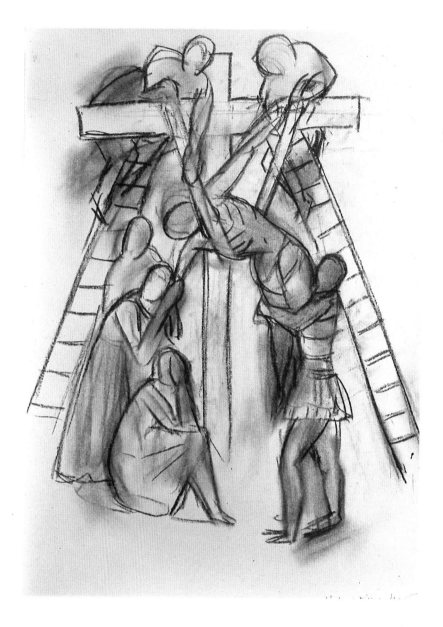

Blue Nude
1952

Beyeler Collection, Basel

What I dream of is an art of balance, of purity and serenity, devoid of troubling or depressing subject matter, an art which might be for every mental worker, be he businessman or writer, like an appeasing influence, like a mental soother, something like a good armchair in which to rest from physical fatigue.

Extract from 'Notes of a Painter'
La Grande Revue, 1908

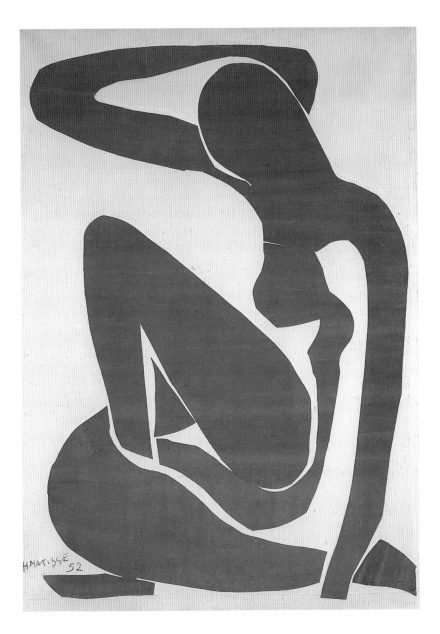

L'Escargot
1953

Tate Gallery, London

The chief function of colour should be to serve expression as well as possible. I put down my tones without a preconceived plan. If at first, and perhaps without my having been conscious of it, one tone has particularly seduced or caught me, more often than not once the picture is finished I will notice that I have respected this tone while I progressively altered and transformed all the others. The expressive aspect of colours imposes itself on me in a purely instinctive way. To paint an autumn landscape I will not try to remember what colours suit this season, I will be inspired only by the sensation that the season arouses in me: the ice purity of the sour blue sky will express the season just as well as the nuances of foliage. My sensation itself may vary, the autumn may be soft and warm like a continuation of summer, or quite cool with a cold sky and lemon-yellow trees that give a chilly impression and already announce winter.

<div align="right">

Extract from 'Notes of a Painter'
La Grande Revue, 1908

</div>

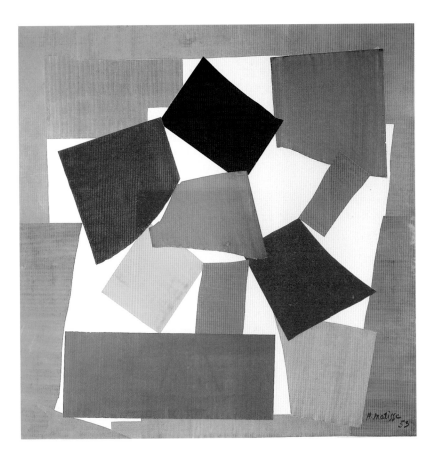

Self Portrait
1937

The Baltimore Museum of Art: The Cone Collection,
formed by Dr Claribel Cone and Miss Etta Cone of Baltimore, Maryland

I am getting my health back. I even had a painting session from
2 to 6.30 – I shouldn't have spent five hours at it, but it was going
so well that I felt I mustn't stop; I didn't feel any the worse for it
afterwards. I did not have a bad night, but I don't think I am going
to set off in search of adventure, I'm simply coasting as I try to get
back into it. I hope I'll reach the point where I'm out of my depth,
and then the only way out will be to venture into the unknown.

Letter to Louis Aragon, 24 August 1942

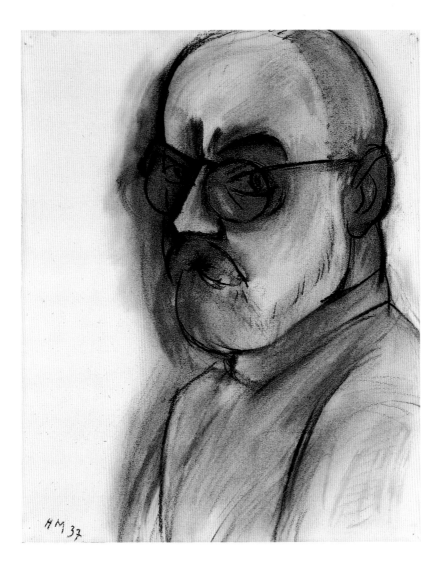

[77]

CHRONOLOGY

Henri Matisse
1869-1954

1869 Born at Le Cateau-Cambrésis, son of a grain merchant.

1882-7 Studies at the Lycée St Quentin.

1887-8 Studies law in Paris. Returns to St Quentin to become a clerk in a law office.

1890 Begins painting while convalescing after appendicitis. Gives up studying law in favour of art.

1890-2 Studies at the Académie Julian under Bouguereau.

1892-8 Studies under Moreau at the École des Beaux-Arts.

1895-7 Spends summer in Brittany with Emile Wéry.

1898 Marries Amélie Parayre. Together they visit London, Corsica and Toulouse.

1899 Meets Derain while studying at the Académie Carrière.
Works as a part-time decorator. Despite great poverty, purchases Cézanne's 'The Three Bathers' which is to influence him greatly.

1901	Exhibits at the Salon des Indépendants.
1903	Exhibits at the Salon d'Automne. Meets Vlaminck and Signac.
1904	Spends the summer working with Signac and Cross at St Tropez.
1905	Exhibits with other Fauves at the Salon d'Automne.
1908	Writes 'Notes of a Painter'.
1907-14	Travels extensively in Italy, Germany and Spain; also visits Moscow. His work is now being shown all over Europe.
1914-18	During the War he divides his time between Paris and the South of France.
1920s	Lives in Paris and Nice with occasional trips abroad to Tahiti, Italy and New York.
1930-2	The Barnes Mural.
1943	Moves to Vence. Continues to work as a sculptor as well as a painter.
1948	Works with the cut-out coloured papers.
1948-51	Commissioned to do the decorations for the Chapelle du Rosaire, Vence.
1952	Musée Matisse at Le Cateau-Cambrésis inaugurated.
1954	Dies in Vence.

ACKNOWLEDGEMENTS

The editor and publishers would like to thank the following for their help in providing the photographs of paintings reproduced in this book:

Albright-Knox Art Gallery, Buffalo, New York (p61)
Baltimore Museum of Art (pp7, 10, 49, 55, 59, 77)
Beyeler Collection, Basel (p73)
Bridgeman Art Library (pp21, 37, 39, 57, 67, 75)
Chapelle du Rosaire des Dominicaines, Vence (pp69, 71)
Hans Hinz (pp53)
Honolulu Academy of Arts (p63)
Musée Matisse, Nice (p65)
Museum of Modern Art, New York (pp35, 43)

Museum of Painting and Sculpture, Grenoble (p31)
National Museum of Modern Art, Paris (frontispiece, pp9, 15, 23, 33)
State Museum of Art, Copenhagen (pp19, 27)
Statens Konstmuseer, Stockholm (p41)
Stedelijk Museum, Amsterdam (p51)
Tate Gallery, London (pp25, 45)
Whitney Art Gallery (cover, p29)
Yale University of Art (p47)

We would also like to thank the publishers of the following books for access to the material contained in them which has been reproduced in this volume:

Henri Matisse, Writings and Ideas on Art D. Fourcade (ed), Hermann, Paris 1972
Matisse en France: Henri Matisse, Dessins, Thèmes et Variations L. Aragon, Marin Fabriani 1943

Matisse's writings:
'Notes of a Painter' First published in *La Grande Revue*, Paris 1908; translated into English by Margaret Scolari and published in 'Henri Matisse' A.H. Barr in *Museum of Modern Art Catalogue* New York 1931
Statements to Tériade 1929–30

Translations from the French by Anne Dobell

Every effort has been made to contact the owners of the copyright of all the information contained in this book, but if, for any reason, any acknowledgements have been omitted, the publishers ask those concerned to contact them.